T0126556

Drawing on the Past

An Archaeologist's Sketchbook

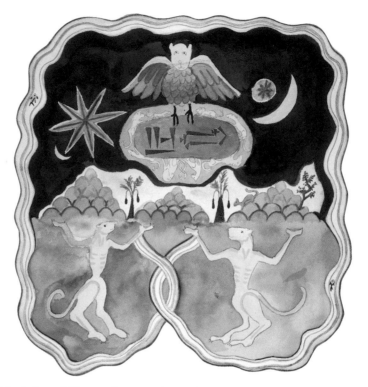

Frontispiece. "The Lion in Sumer." The cuneiform *ur-mah* means lion in Sumerian. The bronze lion-headed Anzu bird stays in the lapis blue sky, while the sweet waters of the Abzu flow from the place where Proto-Elamite lions hold up the world.

Drawing on the Past
An Archaeologist's Sketchbook

Naomi F. Miller

University of Pennsylvania Museum
of Archaeology and Anthropology

Copyright © 2002
By the University of Pennsylvania Museum
of Archaeology and Anthropology
33rd and Spruce Streets
Philadelphia, PA 19104
All Rights Reserved

Library of Congress Cataloging-in-Publication Data

ISBN 1-931707-27-8

Printed in the United States of America

To my parents

Abraham and Mildred Miller

who have always provided unlimited
paper, paint, and love

Contents

Illustrations . ix

Foreword, Patty Jo Watson . xiii

Acknowledgments . xvii

Drawing on the Past . 1

 Malyan, Iran . 10

 Gordion, Turkey . 27

 Euphrates Projects (Turkey and Syria) 60

 Anau, Turkmenistan . 74

Readings . 81

Pronunciation Note . 83

About the Author .85

Illustrations

Plates

"The Lion in Sumer" . *frontispiece*

1 Map of Near Eastern sites mentioned in text . 2

2 Groningen. 7

3 Laying a sidewalk, the Dutch way . 8

4 Dutch landscape with cow . 9

5 Landscape near Malyan, Iran . 10

6 The village of Malyan . 12

7 Shiraz street scene . 13

8 Mindy bargains for buckets in the Shiraz metal bazaar . 13

9 Bill rides out to the excavation . 14

10 Building a new house compound. 15

11 "Surveying the Tepes" . 16

12 "Surveying the Tepe" . 16

13 "Find 19343" . 17

14 Carol, the registrar, confers with Janet, the artist . 24

15 "A Day at the Dighouse" . 28

16 Yassıhöyük . 30

17 "Yassıhöyük Triptych"–Kızlarkaya, Thistles, Road. 31

18 Yassıhöyük farm. 32

19	Sakarya valley from the balcony	33
20	View to west from the balcony, wet year	34
21	View to west from the balcony, dry year	35
22	Sakarya valley with sheep	36
23	Farmyard near the dighouse	37
24	Geese and sheep	38
25	A day at the dig	39
26	"Gordion Çorba Lokantası"	40
27	"The Defense of Gordion"	41
28	View from Kızlarkaya cliff to the Midas Tumulus	42
29	Schematic aerial view of the Midas Tumulus in 1997	43
30	Fantasy wildflower garden at the dig house	44
31	Ankara Çay	45
32	Mihalıççık pine forest	45
33	"Jennifer on Transect 6, Dümrek"	46
34	Ohio Bill and the tomb robbers	48
35	Sakarya sunset, ca. 5000 B.C.	49
36	Gordion, ca. 700 B.C.	50
37	The view from Gordion, sunrise ca. 700 B.C.	51
38	Middle Phrygian Gordion, ca. 600 B.C.	52
39	"Su balesi" (water ballet)	53
40	"Gordion Gala," July 10, 1993	54
41	"Midas World / Midas Dünyası"	55

42 "Year Round Fun at Midas World". 56

43 Golf and water-skiing on "Lake Sakarya" at Midas World . 57

44 "Underground Excitement at Midas Lodge". 57

45 Accommodations at the famous Çanak Palas Oteli . 58

46 Yassıhöyük panorama . 59

47 Euphrates River valley near Kurban Höyük . 60

48 On the road between Birecik and Urfa . 61

49 View to Birecik fortress from the opposite side of the river. 62

50 View to the Birecik bridge from park on Euphrates River . 63

51 Morning on the Euphrates north of Birecik. 64

52 Hacınebi village scene . 65

53 Hacınebi view from the excavation . 66

54 "Hacınebi Fantasie" . 67

55 Amanus mountains . 68

56 View from Sweyhat to Hajji Ibrahim and Nefile village. 69

57 Flock grazes, with Jebel Aruda and Lake Assad . 71

58 "Tell es-Sweyhat, the Musical" . 73

59 Facing south, the Kopet Dag mountains . 74

60 Facing north, the desert. 75

61 Ashkabad street scene . 75

62 Camel . 75

63 Anau landscape, 1994: East, North, and South mounds. 78

64 Center City skyline, 1990, Philadelphia . 80

Figures

1 Rattlesnake in desert landscape . 3

2 Gnats . 4

3 "Descent from the Mesa" . 5

4 Archaeological survey in the northern Valley of Mexico . 6

5 View to the village of Malyan . 11

6 Bill on his motorbike . 18

7 Inside a village compound, Iran . 19

8 Jay, Mike, and Matt . 21

9 Iran fantasy landscape . 22

10 Sari; Nani Ebad; Baba Ebad; friend of the family . 23

11 Lake Assad, Jebel Aruda, and sheep . 70

12 Nefile village house . 72

13 Field of telephone poles in the desert, Turkmenistan . 76

14 Passing scene at Anau . 76

15 Turkmen man, Turkmen town . 77

Foreword

Drawing on the Past is a delightful compendium that places the reader in the center of fieldwork action at several major archaeological projects. The author's informative and conversational prose provides a perfect accompaniment for charming sketches and paintings illustrating the highlights and low moments during field research at a variety of sites in Iran, Turkey, Syria, and Turkmenistan. We learn about many aspects of life on the dig: science and scholarship; digging and analyzing; local landscapes and local politics; shopping and cooking; eating and sleeping.

When she was an undergraduate anthropology major at the University of Michigan, Naomi Miller joined an archaeological field project I was helping to direct in west central New Mexico. I can attest that her vivid evocation of the stinging gnats that plagued us for several weeks (Figure 2) is quite accurate (except that the suffering crew members are depicted in their town clothes, which appeared at best only once a week). Moreover, her fanciful rendering of a rattlesnake in a desert landscape (Figure 1) is true to the spirit of El Morro valley as we encountered it back then.

When I myself was a graduate student at the University of Chicago specializing in Near Eastern prehistory, I began collecting and reading autobiographies of archaeologists whose careers had been spent in western Asia. Some of my favorites are—

Digging Beyond the Tigris, by Linda Braidwood
Come Tell Me How You Live, by Agatha Christie (who married the archaeologist Max Mallowan)
Mallowan's Memoirs, by Sir Max Mallowan
Seventy Years in Archaeology, by Sir Flinders Petrie
Still Digging, by Sir Mortimer Wheeler
Thousands of Years, by John Wilson
Dead Towns and Living Men, by Sir Leonard Woolley

Naomi Miller's archaeological autobiography is distinguished from all the above because it is visual rather than textual: it centers upon personally created, eye-witness, and eye-witness-inspired satirical or imaginary images rather than words; and it engages the reader as soon as one's eye falls upon the first of those images.

Anyone who has ever participated in a dig, has ever wanted to, or who just likes to read about archaeology in action will thoroughly enjoy this volume. A big treat awaits you: start turning the pages!

PATTY JO WATSON
Washington University, St. Louis

Patty Jo Watson (right) in New Mexico

Acknowledgments

My participation in the projects described here was made possible by the following project and excavation directors, sponsoring institutions, and funding sources:

Malyan (1974–1978): William M. Sumner; University of Pennsylvania Museum (UPM); National Science Foundation (NSF), National Geographic Society (NGS)

Gordion (1988–): Mary M. Voigt and G. Kenneth Sams; UPM; National Endowment for the Humanities (NEH), NGS, American Philosophical Society, UPM, University of Pennsylvania, Gordion Foundation

Hacınebi (1993–1997): Gil Stein; Northwestern University; NSF, NEH, NGS, Council of American Overseas Research Centers (CAORC)

Sweyhut (1995–): Richard L. Zettler; UPM; NEH, CAORC, University of Pennsylvania

Anau (1994-): Fredrik Hiebert; UPM, Harvard University; NGS

Since 1987, I have had the good fortune to participate in those projects as a staff member of the Museum Applied Science Center for Archaeology at the University of Pennsylvania Museum of Archaeology and Anthropology.

I would like to thank Jülide Aker, Keith DeVries, Abraham and Mildred Miller, and Bill Sumner for letting me reproduce in this book paintings I gave them. I would also like to thank Walda Metcalf for suggesting I put the book together, and Wilma Wetterstrom and Patty Jo Watson for their valuable comments and suggestions. Jennifer Quick, my partner on Dümrek, designed the book. Biomedical Communications, University of Pennsylvania Medical Center (Paul Barrow), produced transparencies of the original artwork for publication.

As an archaeologist, I have had the pleasure of living and working with many people, including Carol Beeman, Ekrem Bekler, Muammer Bektöre, Kurt Bluemel, Ellen Salzman Chase, Jerry Dandoy, Michael Danti, Keith DeVries, Bob Henrickson, Linda Jacobs, Ben Marsh, the Miri family, Janet Nickerson, Jay Nickerson, Michael Nimtz, Jeff Parsons, Jennifer Quick, Matt Stolper, Bill Sumner, Mary Voigt, Mike Whalen, Remzi Yılmaz, Mindy Zeder, and Richard Zettler.

Drawing on the Past

An Archaeologist's Sketchbook

I painted and drew the pictures in this book over the past 30 years or so. With varying degrees of reality and whimsy, they are inspired by my experiences as an archaeologist. In the accompanying text, I explain what it's been like for me, a New Yorker born and bred, to have had the opportunity to travel to and work and live in places far from home (Plate 1).

I started telling grown-ups I wanted to be an archaeologist sometime during elementary school. This generally got a good response. Aside from some reading, I didn't actually do anything about my career aspirations until college. Before college, the farthest I'd ever traveled from New York City was Washington, DC. In an archaeology class I took as an anthropology major at the University of Michigan, one of the professors advised students thinking of becoming archaeolo-

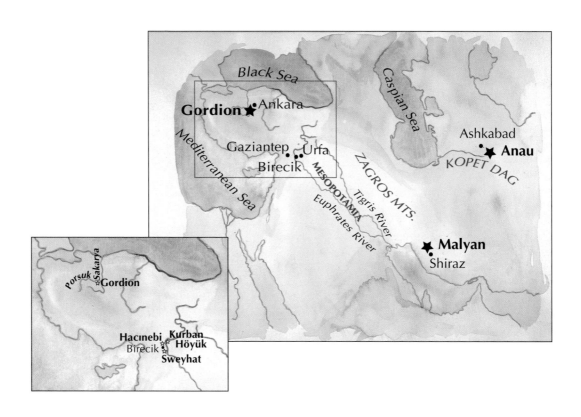

Plate 1. Map of Near Eastern sites mentioned in text.

2

gists to go on a dig to make sure they would like the field work. So my first dig was a field school in Ontario, Canada, where we excavated a Huron village.

I went on my first professional dig in the summer of 1972, the excavation of a 13th-century pueblo in New Mexico. Noteworthy were the many dangers threatening my urban self, like rattlesnakes and gnats (Figures 1, 2), and the thought that if you went out in the morning with no water and got lost, you could die (Figure 3)!

That fall, I returned to the University of Michigan for graduate study in anthropology, concentrating on archaeology. I developed an interest in archaeobotany, the part of

Figure 1. Rattlesnake in desert landscape.

Figure 2. Gnats, bane of our existence on the Cibola project.

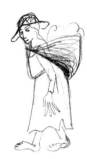

Woman in Mexico

archaeology that deals with the relationship between people and plants in the past. I'd always liked house plants, thanks to early encouragement from my Aunt Ida, but I didn't know much botany until I started studying it. After just one class, though, I began to look at the

4

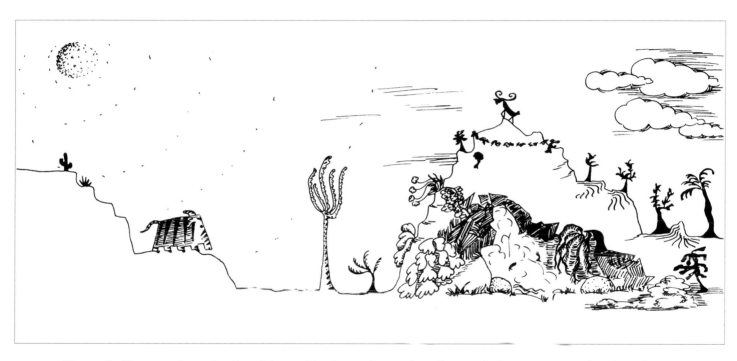

Figure 3. "Descent from the Mesa" (note this picture bears virtually no relation to outer reality, but the creature does appear to be looking for water).

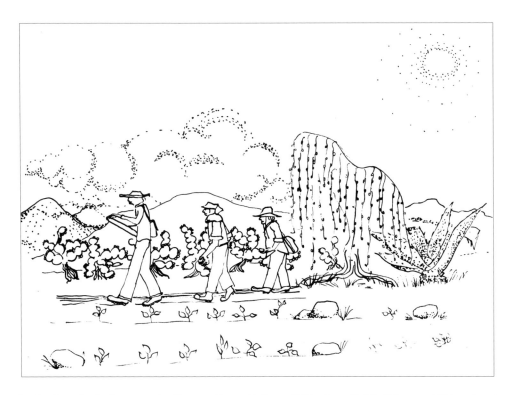

Figure 4. Archaeological survey in the northern Valley of Mexico. Jeff, Mike, and I trudge to our next survey tract in a landscape filled with bean fields, prickly pear cactus, agave, and *pirul* tree.

Plate 2. Groningen. Everyone rides bikes!

natural world in a new way. I started paying more attention to living plants while I was engaged in archaeological site survey in the northern valley of Mexico (Figure 4).

My initial childhood interest in archaeology had been sparked by the ancient civilizations of the Near East. In 1974, I had the opportunity to go to Iran as the archaeobotanist for the Malyan project. After that trip, I spent a couple of months in The Netherlands to learn about the Old World seeds (Plates 2, 3, 4). Although all the landscapes I'd seen since becoming an archaeology student were foreign to my experience, Iran's was the most exotic.

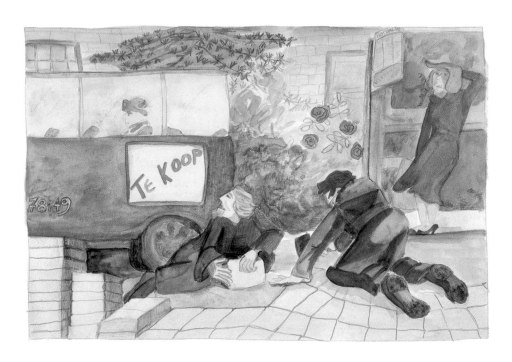

Plate 3. Laying a sidewalk, the Dutch way.

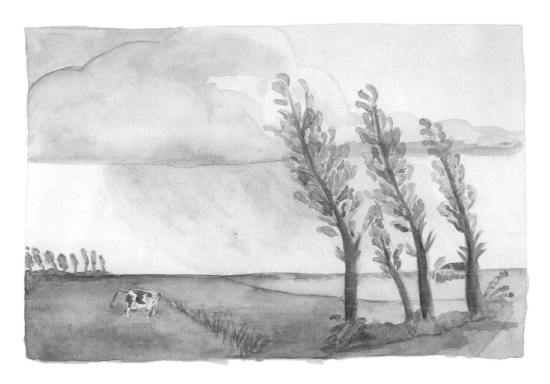

Plate 4. Dutch landscape with cow.

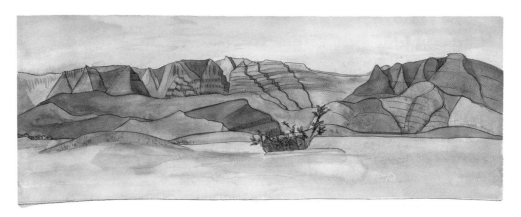

Plate 5. Landscape near Malyan, Iran. Eroded, bare slopes border the flat valley bottom. The only trees are in groves in or near villages.

Malyan, Iran

In 1974, the Malyan project included about 20 excavators and support staff. One of our first tasks was setting up the dig.

We were based at the village of Malyan (Plates 5, 6), about an hour and a half by car from the nearest city, Shiraz, which was our supply town (Plate 7). As the junior members of the team, Mindy

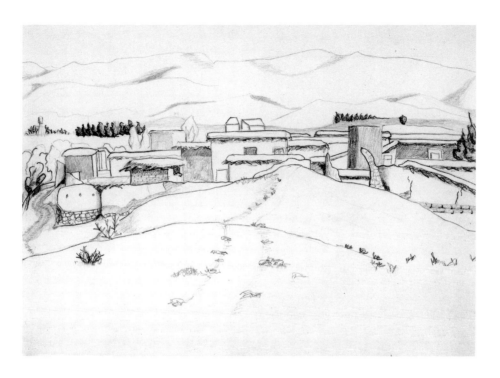

Figure 5. View to the village of Malyan from the melted remains of the ancient mud-brick city wall.

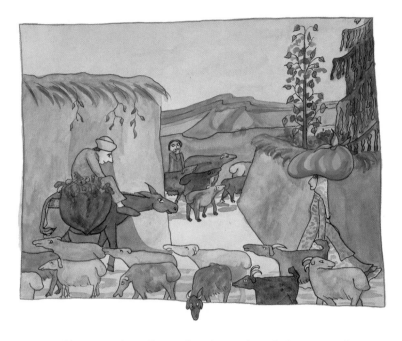

Plate 6. The village of Malyan. The inhabitants make a living by farming and herding.

and I were sent to the bazaar to buy equipment. Mindy actually spoke some Persian, so she negotiated while I watched. In the metal bazaar, we purchased sieves and buckets made from cans with metal handles added (Plate 8).

The present-day village of Malyan sits over part of the archaeological site (Plate 9, Figure 5). We lived there to be close to the site. Our compound across the street from the walled part of the village was originally a garden and tea house, and the project added mud-brick room blocks built to suit.

Once we set up the household, it was time to work. Malyan was like most of the projects I've participated in, with a 9- or 10-hour work day including about 7 hours of excavation, 6 days a week. (It's not as bad as it may

Irrigation worker

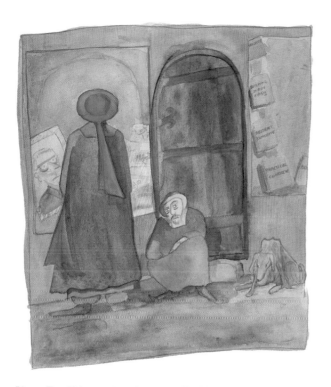

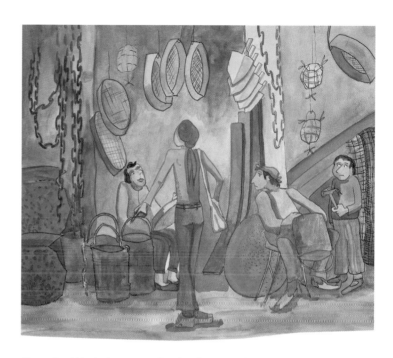

Plate 8. Mindy bargains for buckets in the Shiraz metal bazaar.

Plate 7. Shiraz street scene. In the 1970s, all commercial establishments displayed pictures of the Shah.

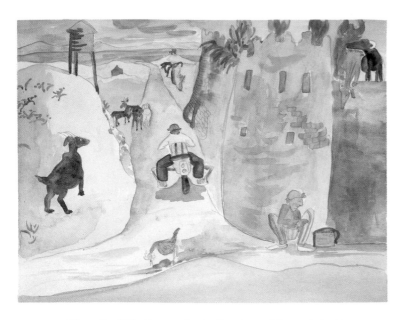

Plate 9. Bill, the project director, rides out to the excavation from the village of Malyan. The ancient city wall is on the left, the modern village wall on the right.

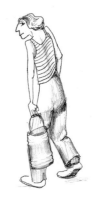

Archaeologist carrying bucket

sound, since we hire local people to shop, cook, do the laundry, and generally maintain the household.) I set up the flotation tank for retrieving plant material in the back, where I could watch the passing scene and the passing scene could watch me (Plate 10).

The archaeological site of Malyan was the ancient city of Anshan. For its time, about 4000–5000 years ago, Anshan was a large settlement. The earlier levels are assigned to the Proto-Elamite period, which has an as-yet undeciphered writing system. Later levels are associated with the Elamite civilization, which was contemporary with that of Sumer

in Mesopotamia. The site is a mound (*tepe* in Persian). Like many sites in the Near East, it was formed by the gradual build-up and decay of mud-brick buildings. This fact answers one of the first questions people ask an archaeologist: How do you find sites and know where to dig? Answer: You systematically walk (or ride) around doing "archaeological survey." On a flat valley bottom, it's not that hard to find archaeological mounds suitable for excavation because they are visible from a distance (Plate 11). Close up, potsherds on the surface help date the sites.

An archaeologist chooses a site for excavation based on his or her geographical and chronological interests. Before putting pick or spade to soil, we establish a grid

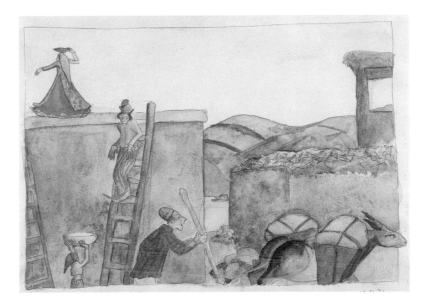

Plate 10. Building a new house compound outside the old village wall. Construction was typically out of mud brick, covered with mud plaster and roofed with packed mud.

Surveying the tepes

Plate 11. "Surveying the Tepes." Of course, *real* archaeological mounds are not pointed tetrahedrons.

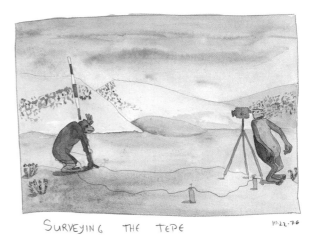

SURVEYING THE TEPE 10·22·76

Plate 12. "Surveying the Tepe." I drew this after hearing about how laying out a couple of trenches had gone one unfortunate day.

Plate 13. "Find 19343." It seemed that there would be no end to the tablets and tablet fragments coming out of the Middle Elamite building, as Linda kept working away. Each fragment got its own registration number.

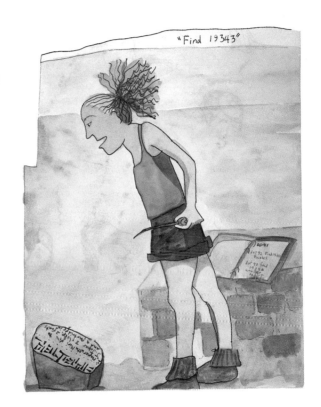

"Find 19343"

system (in the Near East, commonly based on 10 m x 10 m squares). The placement of particular excavation units is guided by surface indications—potsherds may suggest the date of the deposits below, or high spots may suggest the presence of large buildings or a particularly long period of occupation. Archaeologists dig in squares or rectangles because doing so makes it easier to

Fat-tailed sheep

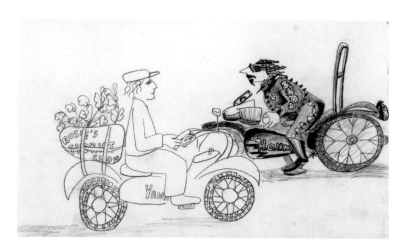

Figure 6. Malyan is so big that the Director (Bill) needed a motor-bike to get from trench to trench expeditiously. The machine putted along at a moderate rate, but I always wondered whether Bill might have had a different image he wanted to project.

draw plans and keep track of where things come from. But it's not always as easy as it looks to get a right angle (Plate 12)! Part of the problem at Malyan was that the ancient city of Anshan was very big, nearly a mile in diameter (1.4 km) (Figure 6). Without electronic surveying equipment, it is particularly difficult to record the location of new trenches accurately on the overall site map.

After we lay out the trenches, we can start excavating. A lot of the heavy work is done by local workers (usually men and boys, but sometimes women) with pick, shovel, and wheelbarrow. Fallen and melted mud brick is just a little bit less dense than a mud-brick wall

 or a compacted earth surface. The most skilled members of the crew can trace out walls and floors with the big pick. Experienced workers, archaeology students, and professionals all get a chance to work with hand picks and, yes, dental tools, too. If you're the supervisor, the day-to-day fun is figuring out where the walls, floors, pits, and other features are.

Until they are washed, one dirty potsherd looks much like another. Every so often something exciting (that is, out of the ordinary) turns up—say, an "archive" of clay tablets with cuneiform writing. That happened during the 1974 season (Plate 13). The first

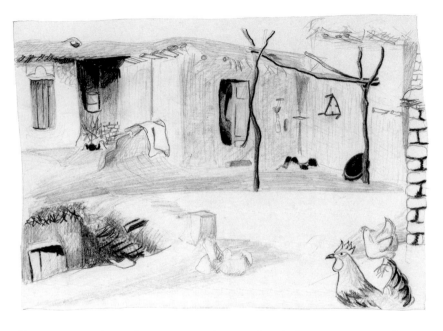

Figure 7. Inside a village compound, Iran. People live on the **second** floor, with stable area and open courtyard/barnyard on the ground floor.

day Linda found a few fragments, and a dozen more the next, each one carefully excavated. After a while, it was easy to get a little blasé.

But at least one person—Matt, the epigrapher—seemed happy reconnecting all those tiny fragments. (Matt used to joke about being one of a half-dozen people in the world who couldn't read Proto-Elamite…and cared.) This episode inspired "The Malyan Rag," performed at the 1974 Malyan Revue (based on "Vatican Rag," by Tom Lehrer):

> First you get down on your knees, careful with that pick ax, please,
> We need this whole rigamarole to get the unbaked tablets whole.
> Then get down on your abdomen, how those tablets keep on comin'.
> This is really terrible, they aren't even legible,
> Doing the Malyan Rag.
>
> Then you call in the epigrapher, for to him you think you must defer
> And he says this is quite dandy, but why's the fill so soft and sandy?
> Well, since it is, try taking it slower; take it easy, use the blower.
>
> What a sad plight, Who knows Proto-Elamite?

Figure 8. Jay, Mike, and Matt.
Mike was shy.

Then you get down on your knees, careful with that pick ax, please,
We need this whole rigamarole to get the unbaked tablets whole.
Then get down on your abdomen, how those tablets keep on comin'.
Everybody has his own tablets to *tamiz kon* [clean],
Being quite jolly, engaging in folly, and
Doing the Malyan Rag.

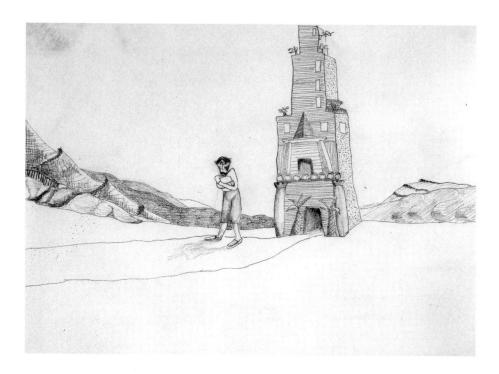

Figure 9. Iran fantasy landscape.

Figure 10. Some people I stayed with at Malyan: Sari, Nani Ebad, and Baba Ebad; also, a friend of the family.

23

Plate 14. Carol, the registrar, confers with Janet, the artist.

To dig is to destroy (an excavation is a bit like an autopsy—you learn the most by dismantling what you study), so recording the finds in the ground and after excavation is very important. In fact, digs commonly have as many specialists (registrar, artist, epigrapher, archaeobotanist, zooarchaeologist) as trench supervisors, to begin dealing with the mass of material (Plate 14).

I don't want to make it sound as though all we did was work. There was plenty of time to just sit and talk. When I had insomnia, I'd wander into the lab at say, 10 o'clock at night, where Jay, Matt, and Mike would be winding down after a long day in the field and lab (Figure 8). And, of course, I found time to draw (Figure 9).

*Bringing fodder back
from the fields*

Milking cow

I had one of my most rewarding experiences in Iran in the spring of 1977. To complete my study and collection of modern plants and to learn something about present-day agriculture and plant use, I spent a couple of months at the home of our assistant cook, Ebadollah (Figure 7). He lived with his wife, child, baby, nephew, and parents (Nani and Baba Ebad—in the village, parents may be called by the name of their oldest son) (Figure 10). Ebad's mother, Nani Ebad, knew a lot about plants, including their names.

One day, I was out collecting, accompanied as usual by a group of interested children. When I would ask them the name of a plant, they generally either answered or simply said they didn't know. I showed them a small plant with a flat, almost heart-shaped seedcase (*Veronica*). At first they just giggled, but eventually one of them said what I heard as "*tesh pir zan*." Well, I knew *pir zan* meant old lady, and the shape of the seedcase gave me a pretty good idea about *tesh* When I showed it to her, Nani Ebad surprisingly claimed not to know the plant's name. Her husband, Baba Ebad, said something like, "Oh come on, you know what that is. It's *tesh pir zan*" (and everybody laughed). Inquiringly, I pointed to my rear end.

Irrigation worker

25

Iran: mountain chain

Living in the village gave me a useful idea about the archaeological plant remains. Namely, the source of many charred seeds in the archaeological deposits was dung burned as fuel. That insight explained an odd characteristic of my samples: some time between 3000 and 2000 B.C., the proportion of charred seeds relative to wood charcoal increased more than ten-fold. What I like to call the world's first alternative energy source—dung fuel—had become increasingly important with population growth and the development of fuel-intensive technologies like metallurgy in the third millennium B.C. (Bronze Age).

I finished fieldwork at Malyan in 1978, just before the Iranian Revolution.

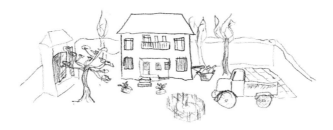

Gordion dig house

Gordion, Turkey

Gordion was the home of the historical Midas, the king of Phrygia (central Anatolia). In the main excavation area at Gordion, the structures visible today date to about 800 B.C., but the site has occupation levels that extend at least 1000 years before and after the Phrygians. That gives a very long sequence of botanical remains from which I can reconstruct changes in the ancient vegetation and land-use practices

The University of Pennsylvania Museum has sponsored the Gordion project since 1950, and I have been working there since 1988. We have our own compound between the village of Yassıhöyük and the site.

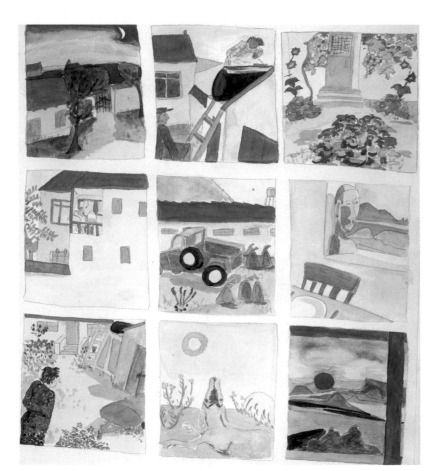

Plate 15. "A Day at the Dighouse." Dawn; the shower tank is filled; the garden grows; tea at 9 on the balcony; bags of sherds and bones get organized; stone head carved many years ago by one of the workmen presides over the dining room; I head for the shower; Ahmak waits for someone to toss a cracker from the balcony; sunset from the balcony.

During the excavation, the day follows a clear rhythm (Plate 15). We rise in the dark, so the excavators can be at the site by the crack of dawn, and come in out of the sun by 1 o'clock. After the excavators leave, the house quiets down and work proceeds at a steady pace. The house staff do various chores, like filling the water tank for showers and preparing tea and lunch. Our cook, Muammer, has the use of the 1961 Jeep pickup truck, with its 1958 Pennsylvania license plate. During the day, the non-excavating archaeological staff do various organizational, recording, and study tasks until the excavators return at 1:30. Then, lunch by 2, tea at 3:30, work from 4 to 6, free time until 7, drinks at 7, dinner at 8, bed at 9, and wake-up at 4:30 A.M.

What with morning tea, afternoon tea, and *kokteyl* hour, a person can spend a lot of time on the back balcony of the house. To the north, the balcony looks to the village and beyond, to the white cliff called "Kızlarkaya" [Girls Rock] (Plate 16). To the west is the Sakarya River valley, in which the site of Gordion sits (Plates 17–21).

The balcony is a good perch for watching Egyptian vultures, storks, owls, prairie dog–like critters,

geese, and passing herds of sheep and cows (Plates 22–24). We have even had some "regulars." Everyone's favorite was the dog whom we came (ironically) to call Ahmak.

Ahmak was unusual. She had a big fluffy tail, unlike the ordinary Anatolian sheepdog. She also was friendly, which until recently was rare for a village dog whose main job is to protect flocks and households. Ahmak would come by every evening at about 6:45, because it didn't take long for her to figure out where the animal-lovers lived. The Turkish proverb, "It is a stu-

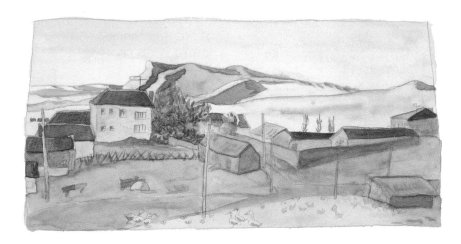

Plate 16. Yassıhöyük from the Gordion dig house, with Kızlarkaya cliff. I painted this picture the year our house got electricity (the village had it many years before we did), so the power poles are pretty important!

30

pid [*ahmak*] dog who expects a biscuit to be thrown to it," clearly did not describe that pooch.

My first responsibility to the Gordion project is as archaeobotanist, but I am part of a team. Plate 25 gives an idea of the complexity of the operation: sherds, bones, and a soil sample are excavated from an ancient pit. The sides of the trench (baulk) show the stratigraphy, or layering, of a sloping trash deposit that overlay the building remains shown at the bottom of the trench. After excavation is completed, the minibus takes the crew back to the house, where the registrar checks all the bags of artifacts and samples. The next day, the village kids (aged about 10–14) come to wash the bones and sherds, which are set out to dry in the sherd yard, where Bob confers with an excavator. The bones and "heavy fractions" from the flotation samples dry.

Plate 17. "Yassıhöyük Triptych"—Kızlarkaya, Thistles, Road.

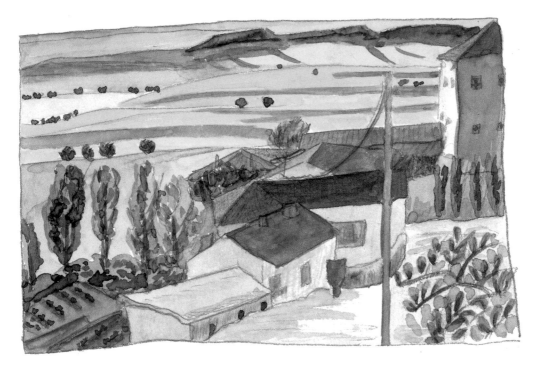

Plate 18. Yassıhöyük. Farm down the hill from the dig house balcony.

Plate 19. Sakarya valley from the balcony.

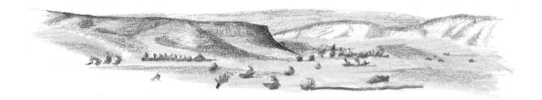

Ellen conserves a pot. Jerry sorts through the bones. Soon enough, the pot is almost as good as new. I float soil samples with my assistant, Ekrem. The pit emptied, the walls brushed, the surface swept…the trench is clean enough to be photographed, and the archaeologist can then plan the features and draw the stratigraphy visible in the baulk. Drawings and photographs bring out different aspects of objects and features, so we use both to document the site.

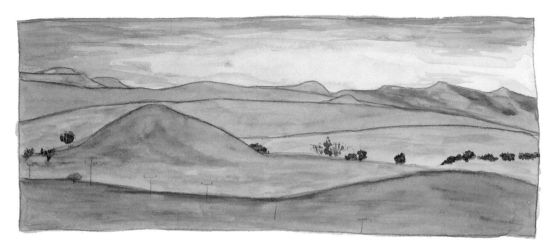

Plate 20. View to west from the balcony, wet year: Kuştepe (part of the ancient Gordion settlement). The spring of 1988 was unusually wet, and when I arrived at Gordion for the first time, I was struck by how green it looked.

The purpose of flotation is to extract plant remains from the archaeological sediments. Of course most organic material decays in the ground. But plant parts burned in a fire may be preserved in charred form if they are not exposed to oxygen during burning. Charred wood and seeds float; stones, dirt, and artifacts sink.

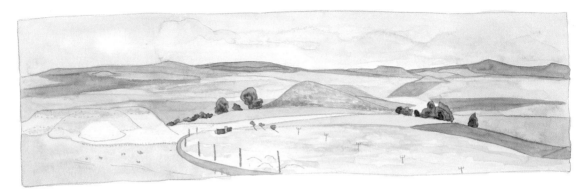

Plate 21. View to west from the balcony, dry year: the flat City Mound of Gordion and Kuştepe. By June 1989, the results of a spring drought were apparent.

You can either scoop up the plant remains with a sieve or let the floating material overflow into a cloth. I used the latter system at Gordion. Plate 26 shows the spot at the base of the ancient city mound where we floated the soil samples. Water flowed from the river through a pump, up to the tank. The water gets pretty muddy after

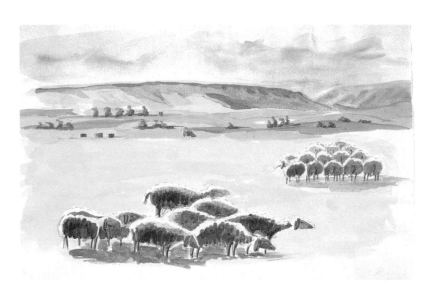

Plate 22. Sakarya valley with sheep. The valley bottom is not farmed in this spot, but flocks graze on it as they pass by heading to greener pastures.

you pour a bucket of earth into the tank, so my assistant and I used to joke about opening up a soup restaurant, which would sell "mud soup," "charcoal soup," "fish soup," "algae soup," and so on.

To really understand the ancient remains, it is helpful to know something about the modern plant cover. That gives an archaeobotanist a good excuse to walk about, collecting seeds and plants from the surrounding countryside and generally getting a feel for the landscape as it is

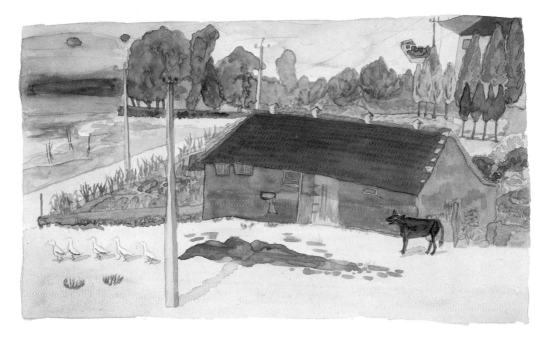

Plate 23. Farmyard near the dighouse. The old building was a barn. Every year, the farmer would dig out a year's worth of sheep dung (a fine fuel). Several years ago, the structure was expanded and is now a chicken coop.

 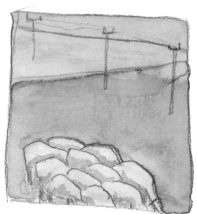

Plate 24. Geese in the village of Yassıhöyük hiss as you walk by (left). Sheep passing by our house (above).

today. The modern vegetation gives clues about what once grew in the area. To identify the ancient charred material, I compare the archaeological specimens with modern seeds and wood.

Plate 25. A day at the dig. Digging the stuff up is just the beginning. You have to get the potsherds, bones, soil samples, and other artifacts home, process them as the beginning of analysis, conserve them. And, after the trench is cleaned, you have to draw all those pits, walls, and features that you are about to destroy on the way down to the lower levels!

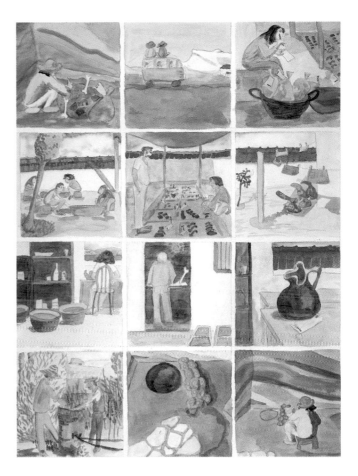

One day, I was collecting plants in the main excavation area of Gordion. Tourists can view the excavated ruins from the top of the mound, but they are not permitted within the perimeter of the barbed-wire fence because the wall stubs and other remains are fragile—the exposed stones would not last long with heavy foot traffic.

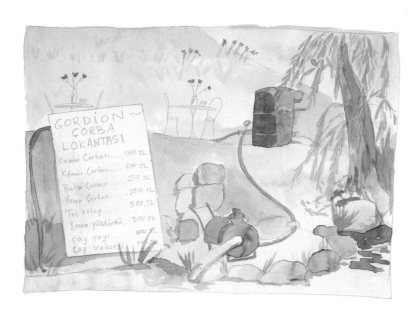

Plate 26. The flotation setup at Gordion/Gordion soup restaurant ("Gordion Çorba Lokantası"). *Çay* means both "tea" and "stream" in Turkish.

Imagine my dismay, then, when a whole troop of new recruits visiting from the nearby army base started to come down into the excavation (Plate 27). I started waving my arms, yelling *"Dur! Dur!"* [Stop! Stop!], and as I tried to explain what the problem was, their officer said to just speak English (a good thing, too, as I didn't know much Turkish at the time), and then he called the troops off.

The Gordion settlement remains comprise just a small part of the archaeological sites in the region. In Phrygian times, the rulers were buried in earthen mounds (tumuli), about a hundred of which are still visible in the valley. The biggest one, at 53 meters (about 175 feet), is called the Midas Tumulus (Plate 28).

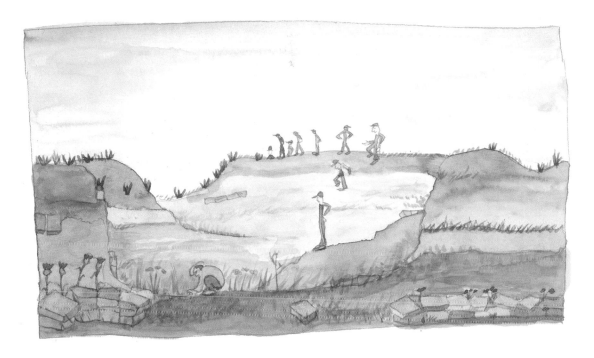

Plate 27. "The Defense of Gordion." I was collecting plants in the excavated part of Gordion when some army recruits came over the fence. I persuaded them to leave peacefully!

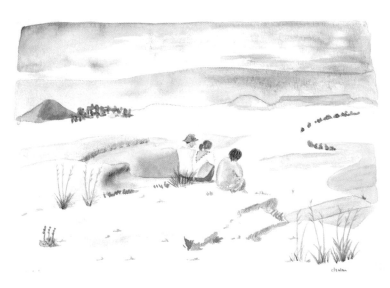

Plate 28. View from Kızlarkaya cliff to the Midas Tumulus, the village of Yassıhöyük (left) and ancient Gordion (right).

I am drawn to the stark setting of these monuments. Especially at dawn and dusk, the irregularly spaced clusters of rounded hillocks can be a little unsettling—they look almost natural, but not quite. This landscape, with its underlying feeling of mystery, inspired a conservation project. One day after work, Keith took me past Kızlarkaya, the white cliff, to a small spot of relatively undisturbed grassy steppe vegetation. It was so pretty and so different from the rest of the landscape, which consisted of agricultural fields or degraded pasture, I started to imagine amber waves of grass growing a little closer to town—on the Midas Tumulus. My big chance came when the authorities expressed concern about erosion on the tumulus. I suggested encouraging plants to grow there by fencing the entire mound, and about a year later, they did just that.

With some exaggeration, I call this attempt to revegetate the Midas Tumulus the Gordion "Ecopark" (Plate 29). The fence has worked very well, but there are erosion channels and steep bare spots. Kurt, a perennial-grass specialist, helped us develop a plan to lay mud brick in a few of the channels. With the winter rains, the bricks would gradually melt and allow plants to get a foothold.

Another part of the project was sowing seeds of some of the native plants. Because unprotected areas have so few plants, our caretaker, Remzi, and I have been trying to figure out how to develop our own seed sources. To that end, we planted an experimental wildflower garden at the dighouse in 1999. The painting (Plate 30) looks a lot more lush than the plot did in 2000 and 2001, but we have

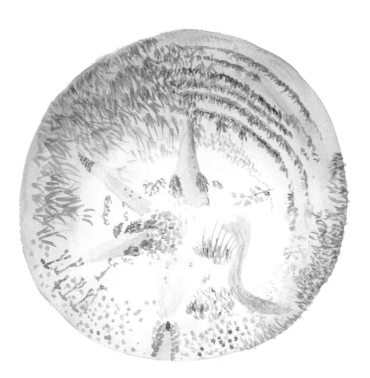

Plate 29. Schematic aerial view of the Midas Tumulus in 1997, showing the different vegetation zones and the main erosion channels. Entrance to burial chamber at bottom of picture (south). A forest of thistles thrives on the southeast side, lush grasses grow on the northwest side, sheep trails pass through wild thyme on the northeast.

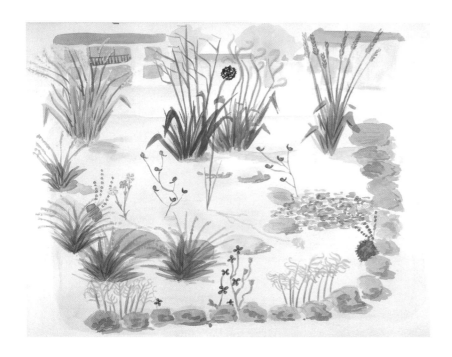

Plate 30. Fantasy wildflower garden at the dig house. Even if I could establish all these plants, they wouldn't all mature at the same time. Clockwise from upper right corner: perennial wild barley, *Consolida*, *Acantholimon*, medusa-head grass, poppy, *Festuca*, *Melica ciliata*, feathergrass, and, in the center, wild onion.

great hopes for a growth spurt. The broader goal of the conservation project is to demonstrate to local farmers and shepherds, as well as to visitors, that at least in principle it is not that difficult to improve pasture while maintaining local biodiversity, and the results would look good, too.

As at Malyan, a dig is not just work. Our "weekend" is Thursday,

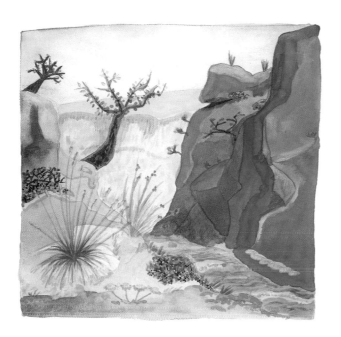

Plate 31. Ankara Çay. I'd intended to cover this painting with a brownish wash, which would have made the colors somewhat more "natural." But I liked it better this way.

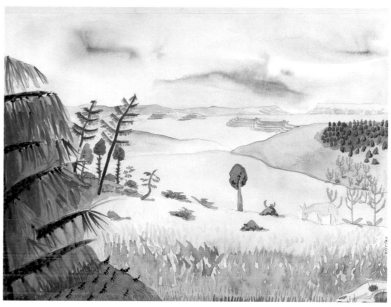

Plate 32. Mihalıççık pine forest. A great place for a picnic, with sunny meadows, cold mountain springs, and shade. The anthills on the forest floor are over a foot high. The forest is managed for timber, and some cleared areas are covered with yellow candelabra-shaped mullein. The eroded sides of the Porsuk valley are in the background.

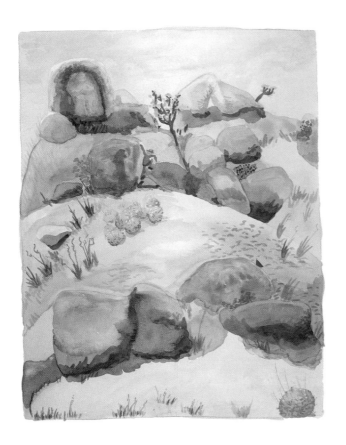

because that is Market Day. The workers like having the day off to do business in town, and it is more convenient for us foreigners, too, so we can go to the bank and shop if we want to.

One of the activities I like best is going on excursions to see the countryside (Plate 31). And one of the best places less than two hours from home is the pine forest (Plate 32). To get there, we drive past the Porsuk River valley and through the oak and juniper scrub, heavily browsed by the flocks. At one place, there are a couple of tall junipers that look like the ones in the Midas Tumulus burial

Plate 33. "Jennifer on Transect 6, Dümrek." After climbing all the way down, we looked up. Was that a rock relief of the Phrygian goddess, Kybele, flanked by lions? Nah. It was just a trick of the light.

chamber. Higher still is the cool shade of the closed-canopy pine forest.

Another thing archaeologists like to do on their days off is…archaeology. For example, not far from Gordion is the Phrygian sacred site of Dümrek. Located on a high promontory above the Sakarya River, it has about twenty roughly carved stone altars. Potsherds—the usual clues for dating sites from surface survey—are sparse. Several of us volunteered to help with an intensive surface pickup. Each team of two had a cloth tape to measure every 10 meters along an imaginary line (transect). We were to pick up and bag all sherds seen along each 10-meter segment, and note the slope (flat, slight, moderate, and so on). Jennifer and I were assigned transect 6 (Plate 33). Along its 250 or so meters, the slope ranged from steep to vertical. There weren't a lot of sherds, either. But the plants were eye-catching.

By now you will have realized that the archaeological life, though interesting, is not filled with Indiana Jones-style, action-packed adventure. But it has its moments. Like the time Bill was doing site survey by motorcycle and saw fresh evidence of illicit excavation on a tumulus not far from the dighouse (Plate 34). Later,

Plate 34. "Raiders of the Lost Tumulus, or Ohio Bill and the Tumulus of Gloom."

taking advantage of the raking light of late afternoon, he stood on the balcony scanning the horizon in the direction of the disturbed tumulus. Were those tomb robbers he was seeing? When he went with the project director to check it out, the only person there was a shepherd who knew nothing. Tipped off by the archaeologists, the authorities set up a stakeout that night. After everyone was abed (must've been 10 P.M.), the police came roaring up to the house and invited Bill to come as an observer

Plate 35. Sakarya sunset, ca. 5000 B.C. (before settlement at Gordion). Oak trees and wolves live on the east side of the valley.

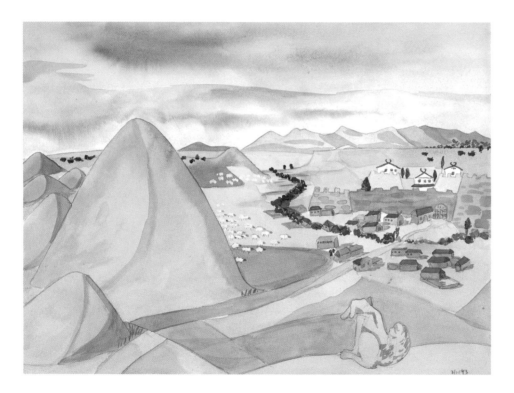

Plate 36. Gordion, ca. 700 B.C. Today, the Sakarya flows on the west side of the site. One of Ahmak's ancestors surveys the scene as the morning light casts a golden glow on the Midas Tumulus. The red tiled roofs are an unintentional anachronism.

Plate 37. The view from Gordion, sunrise ca. 700 B.C. Oak trees still cover the slopes.

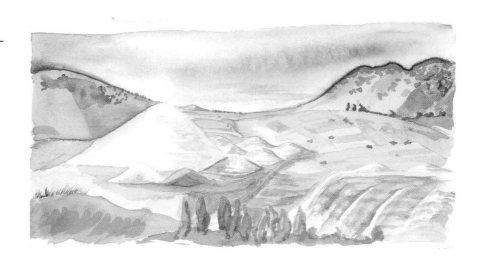

to the station, where they had detained the miscreants. The would-be robbers claimed they were "out fishing," although one of them just happened to have a copy of the Turkish antiquities law in his pocket. The next day, Bill vividly reported the entire story, including the fact that during the interrogation, the chief's gun lay on the desk pointing not at the pot-hunters, but at Bill! In the end, Good had triumphed, once again, over Evil.

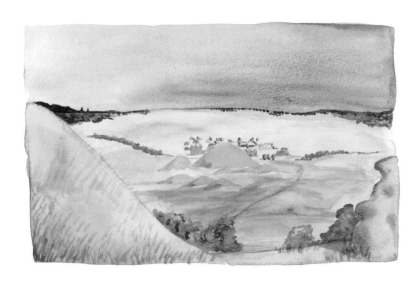

Plate 38. Middle Phrygian Gordion, ca. 600 B.C. The view from the still-forested hillside. The tumulus at the top of the valley (left) is visible from the valley bottom to this day.

A question people sometimes ask me is whether I ponder what life was like for the people whose trash I'm digging up. I don't have much imagination for that, but for fun I have painted a few pictures to start visualizing the ancient landscape based on the plant remains I am finding from Gordion.

One thing that's pretty clear is that there used to be more trees; I have found charcoal of juniper, oak, and pine in the archaeological deposits. The valley bottom itself may never have had much in the way of trees, but scrubby juniper grew nearby. It was cut down, but in 700 B.C. there were trees at least along the Sakarya River, and oak on the farther hillsides (Plates 35, 36).

The Sakarya used to be a meander-ing river. In fact, according to Ben the geo-

morphologist, it meandered from the east side of the site to its current position on the west (Plate 37)! Over the years, team members found traces of settlement outside the city walls to the east. One of the discoveries of the 1990s was that the settlement expanded considerably to the west of the site, as well (Plate 38).

With a typical field season being two months of 6-day work weeks, many digs have a mid-season break. One year, Mary, Jennifer, Mindy, and I took off to the old Ottoman town of Bursa, at the base of Uludağ mountain. Hot and cold springs feed public baths in town. We stayed at the famous Çelik Palas Hotel, which has a beautiful Art Deco tiled *hamam* (bath). Reflections from the central pool make the domed roof a shimmering green. While two fellow tourists sat in one of the hot side basins, we had the big pool of bath-warm water to ourselves, perfect for performing an impromptu "water ballet" (Plate 39).

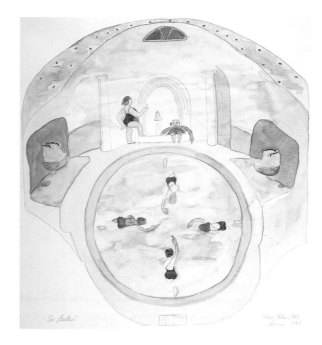

Plate 39. "*Su balesi*" (water ballet) in the Çelik Palas Hotel, Bursa. Clockwise from right: Mindy, me, Mary, Jennifer.

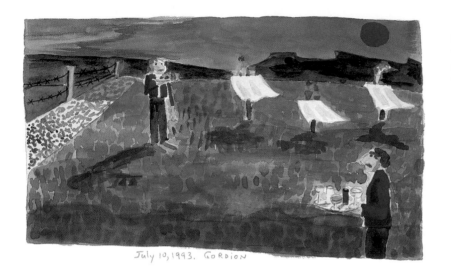

July 10, 1993. GORDION

Plate 40. "Gordion Gala," July 10, 1993. Uniformed waiters serve drinks and hors d'oeuvres on top of the Gordion City Mound (old excavation trench fenced with barbed wire on the left).

At this point you may be wondering, "So who pays for all this fieldwork?" Well, the three major funding sources of the projects I have worked on are competitive grants obtained by the directors of the various excavations from the National Science Foundation, the National Endowment for the Humanities, and the National Geographic Society. Smaller grants supplement the big ones. And private funding sources are also sought. For example, the Gordion project has been fortunate in receiving substantial private support channeled through our sponsoring institution, the University of Pennsylvania Museum. In 1993, fund-raising efforts took the form of a gala party at the site, to which potential donors were invited. There were even rumors that the Prime Minister of Turkey would

54

Plate 41. Entrance to "Midas World/Midas Dünyası." The Phrygian alphabet is related to Greek.

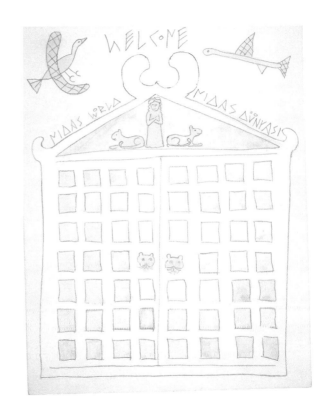

come (as it happened, she never made it to the event). Because of all the important guests, a line of telephone poles was put up between the village and the site (cell phones were not yet available). A big tent with portable dance floor was set up in the low-lying area at the base of the mound. Some of the guests may, to this day, remember the mosquitoes; we archaeologists came dabbed with mostly effective insect repellent. For me, however, the rather surreal highlight of the event was catered cocktails on the mound at sunset (Plate 40).

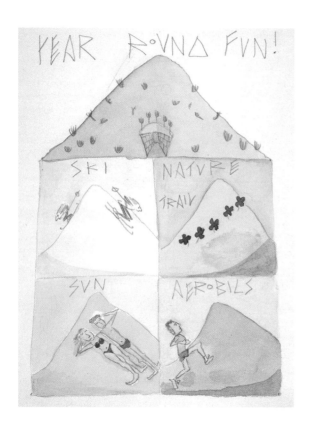

Plate 42. "Year Round Fun at Midas World."

One year, a few team members had a great idea for making money. Why not open a theme park—Midas World? When I heard about it, it seemed a lot more lucrative than the Ecopark is ever likely to be, so I prepared a prospectus. You enter through a Phrygian door-way (based on an actual Phrygian monumental rock carving) (Plate 41). Winter, spring, summer, or fall, there's always something to do (Plate 42). The golf course has interesting hazards, and water-skiers can enjoy the view on "Lake Sakarya," filled behind the new dam (Plate 43). In the evening, visitors can enjoy fine dining and dancing at Midas Lodge, served by old "Golden

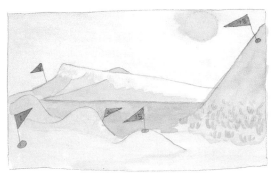

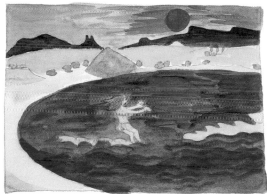

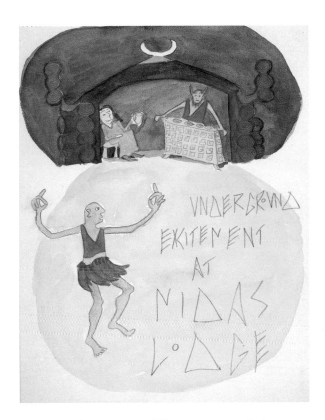

Plate 43. Golf and water-skiing on "Lake Sakarya" at Midas World.

Plate 44. "Underground Excitement at Midas Lodge."

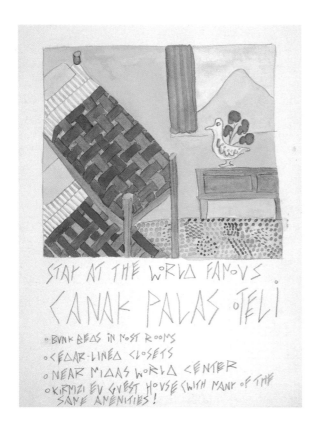

STAY AT THE WORLD FAMOUS
ÇANAK PALAS OTELİ
o BUNK BEDS IN MOST ROOMS
o CEDAR-LINED CLOSETS
o NEAR MIDAS WORLD CENTER
o KIRMIZI EV GUEST HOUSE (WITH MANY OF THE SAME AMENITIES!)

Plate 45. Accommodations at the world famous Çanak Palas Oteli, with a view of the Tumulus.

Touch" Midas himself. The Lodge, underneath the Midas Tumulus, displays exquisite examples of Phrygian woodwork and carpentry (Plate 44). Several accommodation options are available (Plate 45). The Çanak Palas Hotel is the most posh, with its Phrygian-style pebble mosaic floor, attractive duck ceramic vase, and a bed with striped sheets that are too narrow, just like those that *real archaeologists* sleep on! (Actually, the Çanak Palas [Sherd Palace] is one of the store-rooms in our compound.)

Gordion enchants visitors, especially archaeologists (Plate 46).

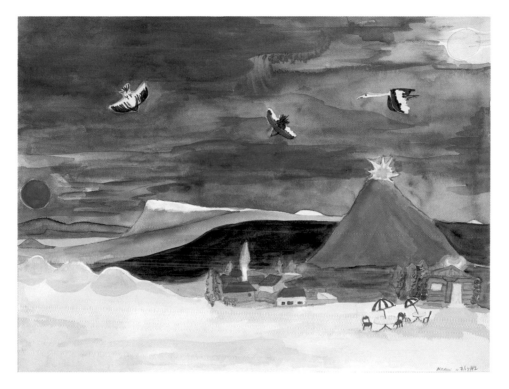

Plate 46. Yassıhöyük panorama. The night of the full moon, some team members climbed the Tumulus and flashed us back at the house. The real tea house in town does not, however, take the form of a Phrygian building. And as Muammer was quick to point out, storks don't fly at night.

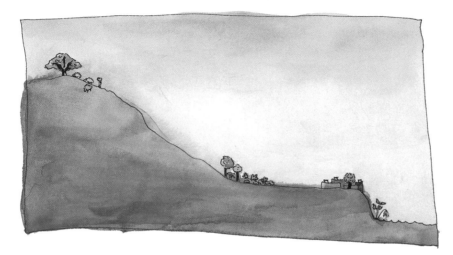

Plate 47. Euphrates River valley near Kurban Höyük, southeastern Turkey.

Euphrates Projects: Turkey and Syria

Another of my long-term ongoing projects involves several sites in the rainfall agriculture zone of southeastern Turkey and northwestern Syria, along the Euphrates River—Kurban Höyük, Hacınebi, and Sweyhat. Due to a large number of hydroelectric projects, the govern-

ments of Turkey and Syria have encouraged salvage excavations. The waters behind the dams have already inundated many sites that lie on the lower terrace of the river. One of the few pictures I painted at Kurban Höyük, where I worked between 1982 and 1984, is a cutaway view of the left bank of the Euphrates, showing its fairly narrow flood plain, a lower terrace with now-submerged village, fields, and orchards, and an upper terrace that was grazed more than farmed. A single old oak tree shows that the climate can support more trees than grow there now—steppe-forest (Plate 47). Away from the Euphrates valley, the land is heavily grazed, with areas of big basalt boulders poking up out of the ground (Plate 48).

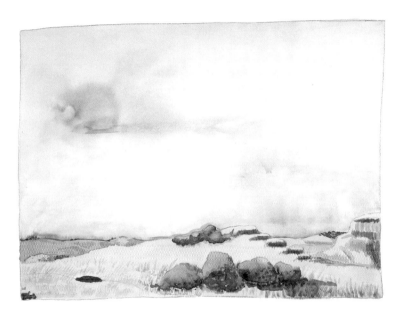

Plate 48. On the road between Birecik and Urfa.

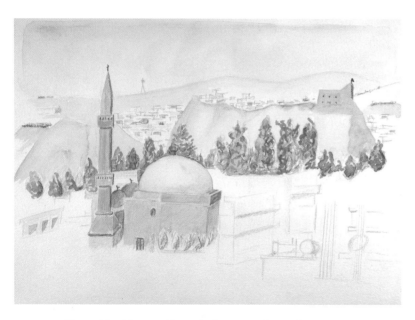

Plate 49. View to Birecik fortress from the opposite side of the river.

In 1993, some years after Kurban Höyük was flooded by the Ataturk Dam, I had the opportunity to return to southeastern Turkey. That lone oak was still there. I was headed to Hacınebi, a few kilometers north of Birecik. Birecik is an old Euphrates river crossing on the main road to Urfa. A medieval fortress, now a ruin, once protected the crossing (Plates 49, 50). Unlike my earlier experience in the southeast, on this dig we lived in town. So every day at 5 A.M. our minibus would take us to the site and village of Hacınebi along the two-lane paved highway cut into the bluffs above the narrow flood plain (Plate 51).

The Euphrates marks something of an ecological boundary—unirrigated pistachio orchards and vineyards are estab-

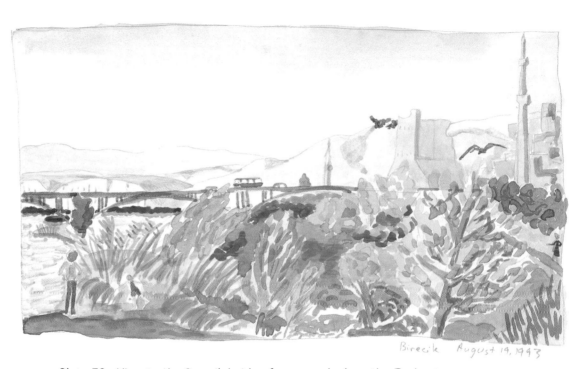

Birecik August 19, 1993

Plate 50. View to the Birecik bridge from a park along the Euphrates.

63

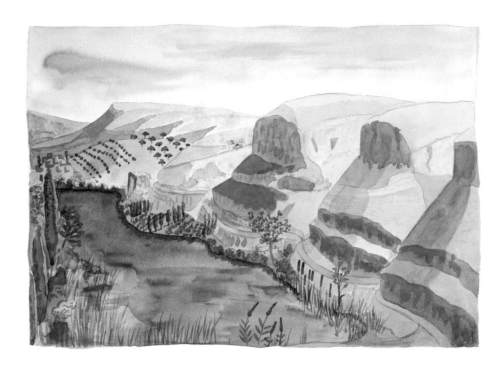

Plate 51. Morning on the Euphrates north of Birecik. Our minibus climbs the bluff on which the ancient settlement and modern village sit. In the background, you can see some vineyards and a pistachio orchard. People garden on the islands in the middle of the river.

lished on the east (Hacınebi) side of the river. On the other side, toward Gaziantep and closer to the Mediterranean climate zone, olive and pistachio production is important. (The best pistachios are said to come from this region west of the river; a secondary meaning for pistachio may be roughly translated as "cute chick," with the same context-dependent negative or positive connotation as in English.)

Present-day Hacınebi village exhibits the traditional architecture of this part of the world—mud-brick or stone structures with flat roofs (Plate 52). In the summer, thick mud-brick or stone walls insulate the rooms, allowing them to remain

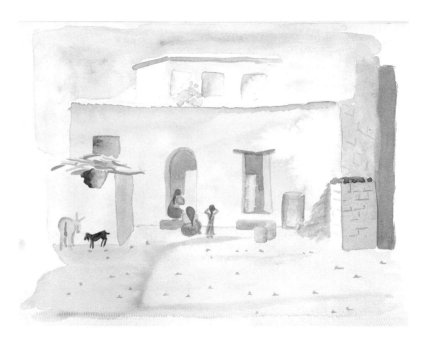

Plate 52. Hacınebi village scene.

65

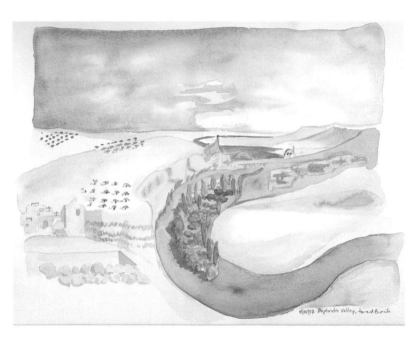

Plate 53. Hacınebi view from the excavation—south to the village, Birecik, and on to Mesopotamia.

cool during the day. At night, it is much more comfortable to sleep outside, and metal bedframes are set up on the roofs. The flat roofs of the mud-brick and stone structures at Hacınebi and Malyan look quite different from the tiled, pitched roofs of central Anatolia.

Ancient Hacınebi was a small fourth-millennium B.C. settlement (somewhat older than Malyan and a good bit older than Gordion). In the northern reaches of Mesopotamia, the material remains reflect both the local culture and possible

66

contact with early Mesopotamian civilizations (Plate 53). Although writing had not yet developed, much visual information was carved into stone seals and impressed into clay sealings.

Another early indication of the civilization yet to come is exemplified by one of the unexpected features of the site–a large stone platform (Plate 54). (Archaeologists usually consider large constructions as evidence of organized community activity.) Deforestation, which may have accompanied the growth of population and

Plate 54. "Hacinebi Fantasie." Landscape about 6,000 years ago. The animals in this picture show up on the seals and seal impressions from the site.

Plate 55. Amanus mountains, with pine forest on the hillsides, vineyards, small fields and garden plots in the valley bottom.

development of metal technology, had not yet happened, so open oak woodland interspersed with agricultural fields probably characterized the landscape.

On one Hacınebi mid-season break, we went to the beach, about four hours west to the Mediterranean. For me, the best part of the trip was going through the Amanus mountains (Plate 55). It looked just like the landscape depicted in the Assyrian palace reliefs that illustrate Sennacharib's campaign there.

Plate 56. View from Sweyhat to Hajji Ibrahim excavation and Nefile village.

Beginning in 1995, the Sweyhat project took me farther south, although still in the rainfall agriculture zone, to the Syrian steppe. Not strictly speaking a salvage project, the excavation did come out of the archaeological surveys conducted before the waters of Lake Assad flooded the Euphrates valley behind the Tabqa Dam. Sweyhat, now about 3 kilometers from the lake, is on an upper terrace of the Euphrates and so was not flooded.

Agriculture here is a very risky endeavor. In the early spring, the fields are bright green and dotted with color from the wildflowers (Plate 56). Sometimes, however, unirrigated crops do so poorly they are not even harvested, and the flocks are allowed to graze them. In a normal or wet year, flocks

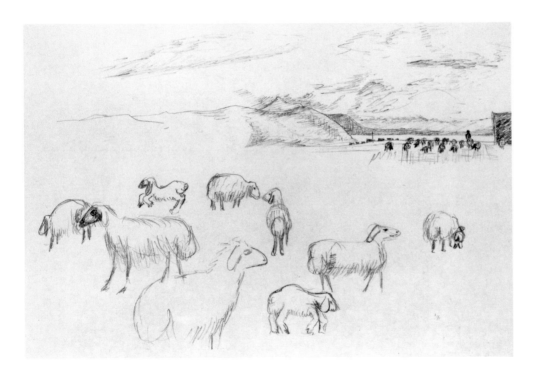

Figure 11. Lake Assad and Jebel Aruda. Flock grazing on field stubble. Fat-tailed sheep are common in Nefile (Syria) and Malyan (Iran), but not at Gordion.

graze on the field stubble after the harvest (Figure 11, Plate 57).

The houses in the village of Nefile, where we live, are more spread out than at Hacınebi, perhaps because its settled nomads prefer to have more space. Like the house shown in Plate 53, the houses in Nefile have two entrances, one for public and one for private use (Figure 12).

About halfway between Nefile and Sweyhat, we had a small satellite excavation, Hajji Ibrahim (Plate 56). The major part of the excavation, however, was at Sweyhat, which was a large town/small city in the third and second millennia B.C. (Bronze Age). As is true today, pastoral production would have been more important than in the moister north, which was more dependent on cultivation.

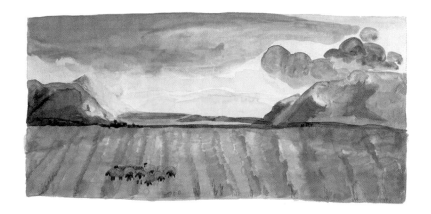

Plate 57. Flock grazes, with Jebel Aruda and Lake Assad in the background.

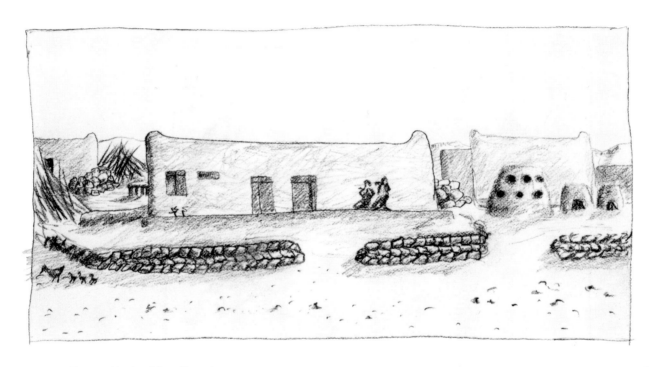

Figure 12. Nefile village house.

Given the relative aridity of the climate, we might expect to see a lot of seeds in the archaeological samples. Indeed, the plant remains were rich in seeds—one sample had over 10,000, each one of which I counted back in the lab at the Museum Applied Science Center for Archaeology, in Philadelphia (my day job). I have to admit I rather like what others might consider the tedium of seed sorting, but I don't think I'd be so willing to do it if I weren't involved in the fieldwork aspect of the projects I partici-pate in (Plate 58).

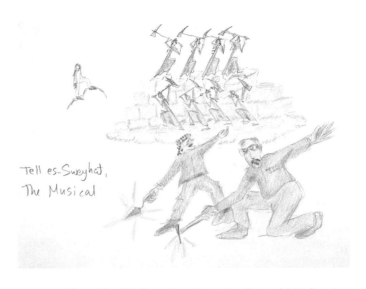

Tell es-Sweyhat, The Musical

Plate 58. "Tell es-Sweyhat, the Musical." Richard and Michael lead the crew. Work on the dig is not as tightly choreographed as this picture may suggest.

Plate 59. Facing south, the Kopet Dag mountains. In Turkmenistan, the main communication routes (rail and road) parallel the mountains.

Anau, Turkmenistan

After many years working in the Near East, I developed a yen to work in Central Asia. My big chance came with the Anau project, in Turkmenistan, in 1994. The topography of the region is striking—the Kopet Dag mountains form the border with Iran to the south (Plate 59), the desert lies to the north (Plate 60, Figure 13), and in between is a narrow strip of irrigable, relatively flat land, where most of the population lives and works (Plate 61).

Anau is a big site, but a small project (Figure 14). Located in that productive piedmont zone, its three widely spaced mounds were occupied in sequence—Anau North (late Neolithic/Chalcolithic),

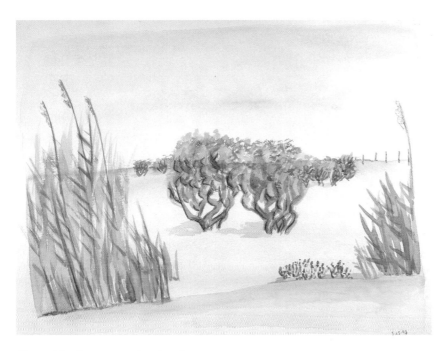

Plate 60. Facing north, the desert.

Plate 61. Ashkabad street scene.

Plate 62. Camel.

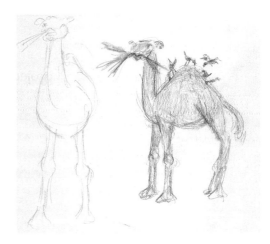

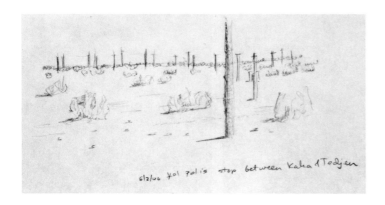

Figure 13. Field of telephone poles in the desert, Turkmenistan.

South (Bronze/Iron Age), and East (Iron Age/Islamic) (Plate 63). A plausible explanation for the shift in settlement is that the local stream (the Anau Su) flowing out of the hills periodically changed course.

The Turkmen language is very similar to Anatolian Turkish (but you do have to be careful; for example, *para* means "money" in Turkey, but "bribe" in Turkmenistan). It was a source of surprise and amusement to both me and my interlocutors the occasional times we could actually understand each other.

One day, we went into the hills along the Anau Su for a picnic. Even though the slopes above the stream were heavily overgrazed, I enjoyed exploring to check out the plants. Along with several familiar faces, there were many others I'd never seen before. There was also some unfamiliar scat, and as I just

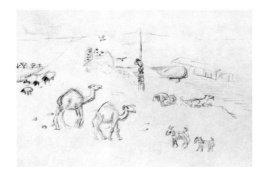

Figure. 14. The passing scene at the Anau excavations.

happened to have a sandwich-sized plastic bag, I picked it up. At first I couldn't imagine what animal it was from, there not being much cover for a large wild herbivore. Then I realized it was probably camel dung! When I showed it to our Turkmen driver and asked, "From camel?" I was a little afraid he'd be offended or think I was strange. But he seemed to think it a reasonable question, and I understood him to say that camel dung is put in special pouches and hung inside houses for good luck or health (Plate 62). In any case, it has joined the other samples in my "dung drawer" in Philadelphia.

Along with historians, paleontologists, and geologists, archaeologists study events at time scales longer than they can personally experience. My branch of archaeology focuses

Figure 15. Turkmen man and cart; town in Turkmenistan.

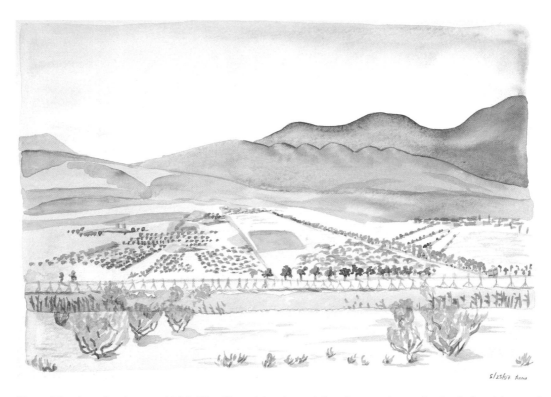

Plate 63. Anau landscape, 1994. The East, North, and South mounds are in the left midground.

Kopet Dag

on tracing long-term human impact on the environment. But I find my imagination lacking when I visit a place just once—whether a traditional village or a big city, my memory of it is static. Even with repeat visits, it can be hard to remember that things change in the most seemingly conservative places.

Yet, small changes were visible even to us foreign archaeologists in the years before the Iranian Revolution of 1979, although we did not recognize their significance.

At Gordion, the patch of "grassy steppe" that inspired the Ecopark is shrinking as a result of agricultural development.

In the Urfa of 1983, if an American stood still on the street a crowd would gather (30 people in about 2 minutes…I timed it), where now passersby scarcely notice a foreigner.

In 1994, the road signs in Turkmenistan were all in Cyrillic script, whether Turkmen or Russian; by 1997, new signs were all in the recently introduced, Latin-based Turkmen alphabet; by 2000, the only Cyrillic to be seen was on dilapidated signs.

Archaeologists may study old dead things, but when your work takes you repeatedly to so many places for extended periods, the people and places you encounter enrich your experience even as they teach you about a world in constant flux (Plate 64).

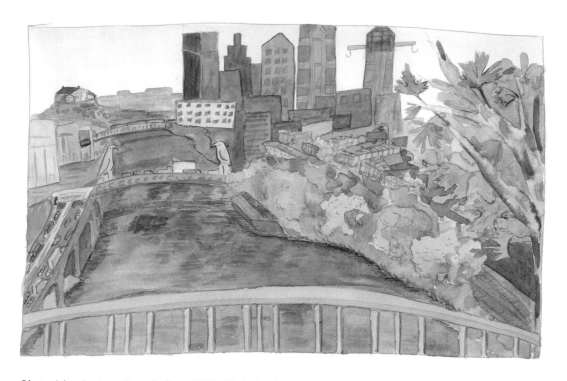

Plate 64. Center City skyline, 1990, Philadelphia. View from the South Street Bridge.

Readings

Websites
University of Pennsylvania Museum: www.upenn.edu/museum/
Naomi F. Miller: www.sas.upenn.edu/~nmiller0/
 For links to project websites:
 www.sas.upenn.edu/~nmiller0/links.html

Malyan
Sumner, William M.
1997 Malyan. In *Oxford Encyclopedia of Archaeology in the Near East*, vol. 3, ed. E. M.
Meyers, pp. 406–409. New York: Oxford University Press.

Gordion
Voigt, Mary M.
1997 Gordion. In *Oxford Encyclopedia of Archaeology in the Near East*, vol. 2, ed. E. M.
Meyers, pp. 426–431. New York: Oxford University Press.

Hacınebi

Stein, Gil

1999 Material Culture and Social Identity: The Evidence for a 4th Millennium B.C. Uruk Mesopotamian Colony at Hacınebi, Turkey. *Paléorient* 25:11–22.

1999 *Rethinking World Systems: Diasporas, Colonies, and Interaction in Uruk Mesopotamia*. Tucson: University of Arizona Press.

Sweyhat

Zettler, Richard L., ed.

1997 *Subsistence and Settlement in a Marginal Environment: Tell es-Sweyhat, 1989–1995. Preliminary Report*. MASCA Research Papers in Science and Archaeology 14. Philadelphia: University of Pennsylvania Museum.

Zettler, Richard L., et al.

1996 Tell es-Sweyhat, 1989–1995. A City in Northern Mesopotamia in the 3rd Millennium B.C. Special section in *Expedition*, Vol. 38, No. 1.

Pronunciation Note

Seven specifically Turkish letters appear in this book: ş is pronounced like **sh** in shovel, ç is pronounced like **ch** in charcoal, c is pronounced like **g** in archaeology, undotted **i** (ı) sounds not quite like **i** in archaeologist, and the soft **g** (ğ) lengthens the preceding vowel but is otherwise not heard. Umlauted **o** (ö) and **u** (ü) are like they are in German.

About the Author

Naomi F. Miller began to draw as soon as she could hold a pencil. About twenty years later she took up the trowel. She is now a Senior Research Scientist at the Museum Applied Science Center for Archaeology (MASCA) in the University of Pennsylvania Museum of Archaeology and Anthropology. She has written many articles and archaeobotanical reports and she co-edited *The Archaeology of Garden and Field* (1994). Several of her drawings appear in *The Basin of Mexico: The Ecological Processes in the Evolution of a Civilization* (1979).